D1269264

Philadelphia Heights

Free LIBRARY OF PHILADELPHIA

Copyright 2007 by the author of this book James A. Pecora. The book
author retains sole copyright to his or her contributions to this book.
Second Edition August 23, 2007

Copyright © 2007 by James Pecora

Published by
James Pecora
P.O. Box 156
Flourtown, PA 19031-0156

ISBN: 978-0-9800038-0-2

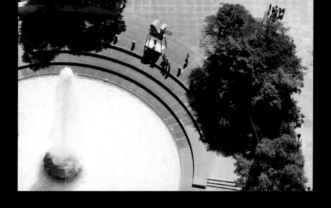

The Blurb-provided layout designs and graphic elements are copyright Blurb
Inc., 2007. This book was created using the Blurb creative publishing service.
The book author retains sole copyright to his or her contributions to this book.

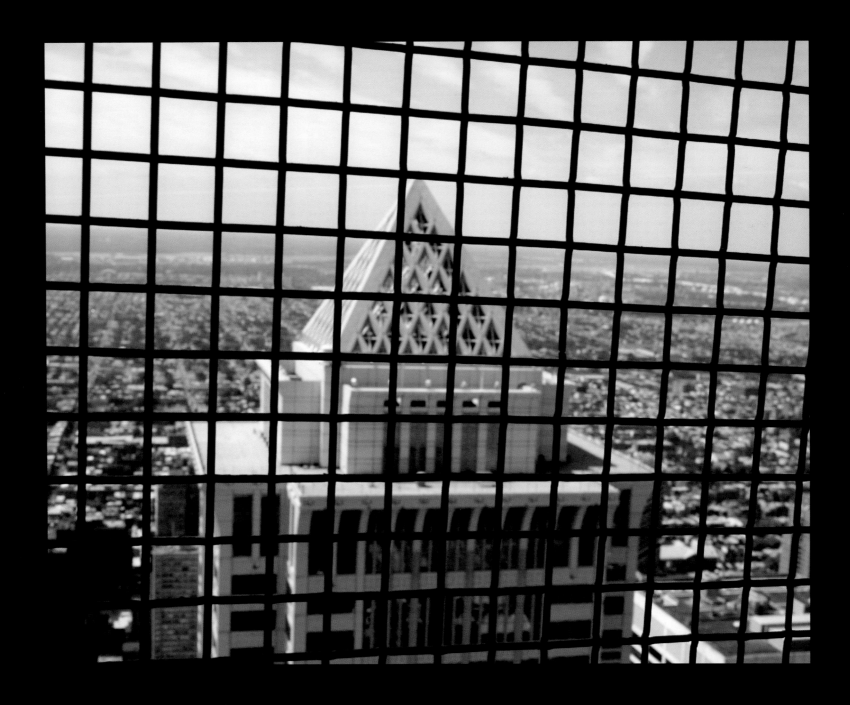

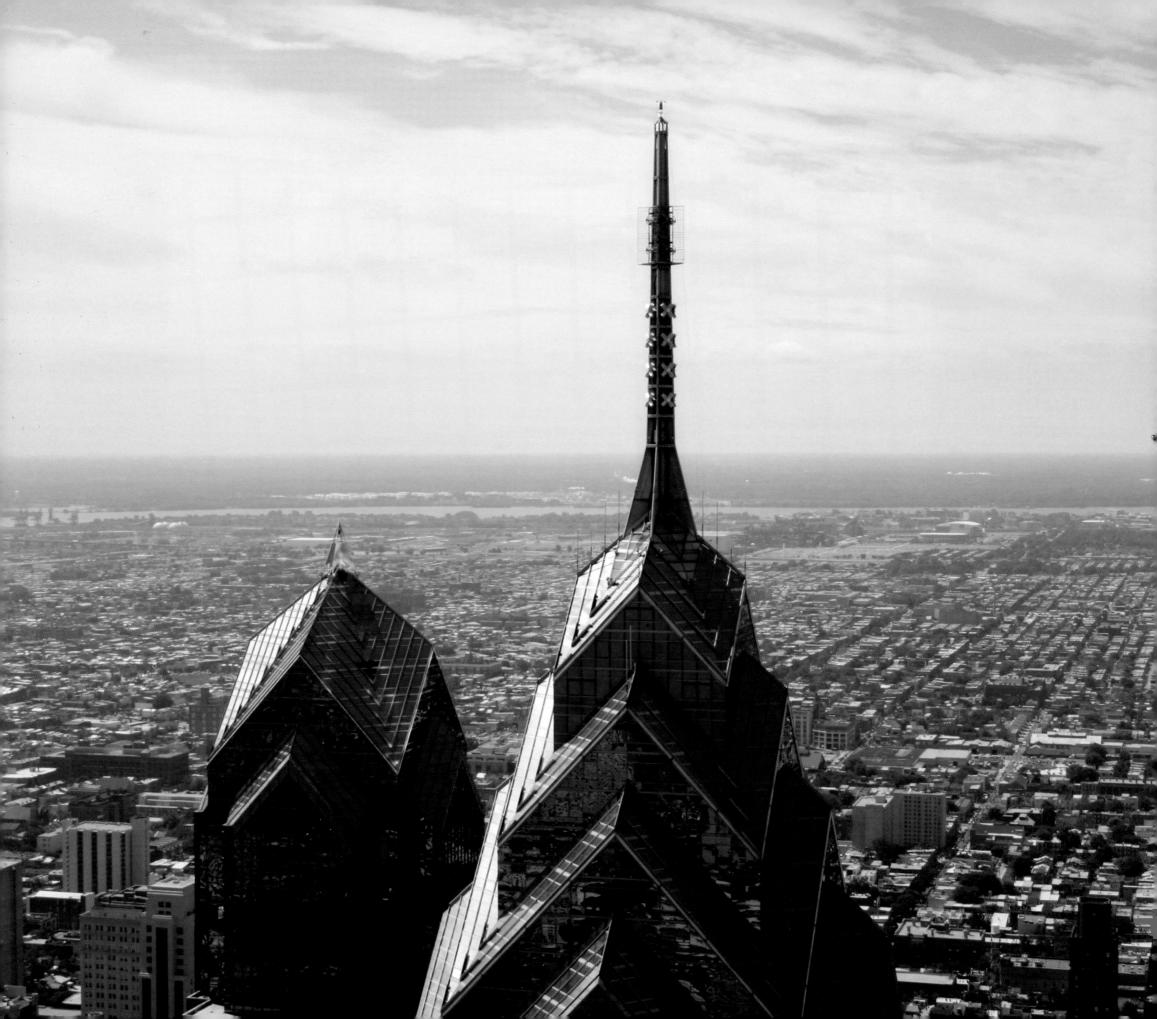

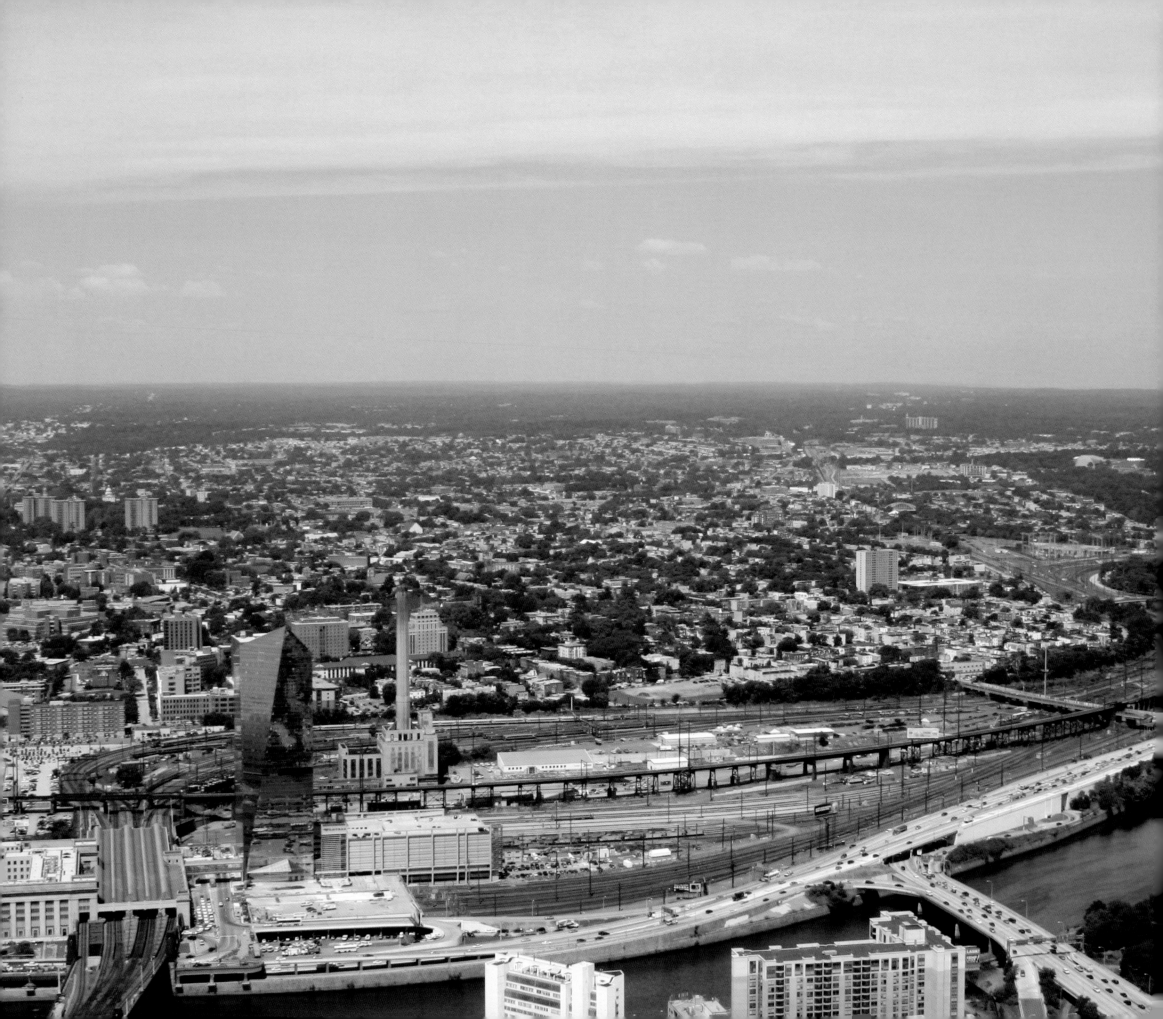

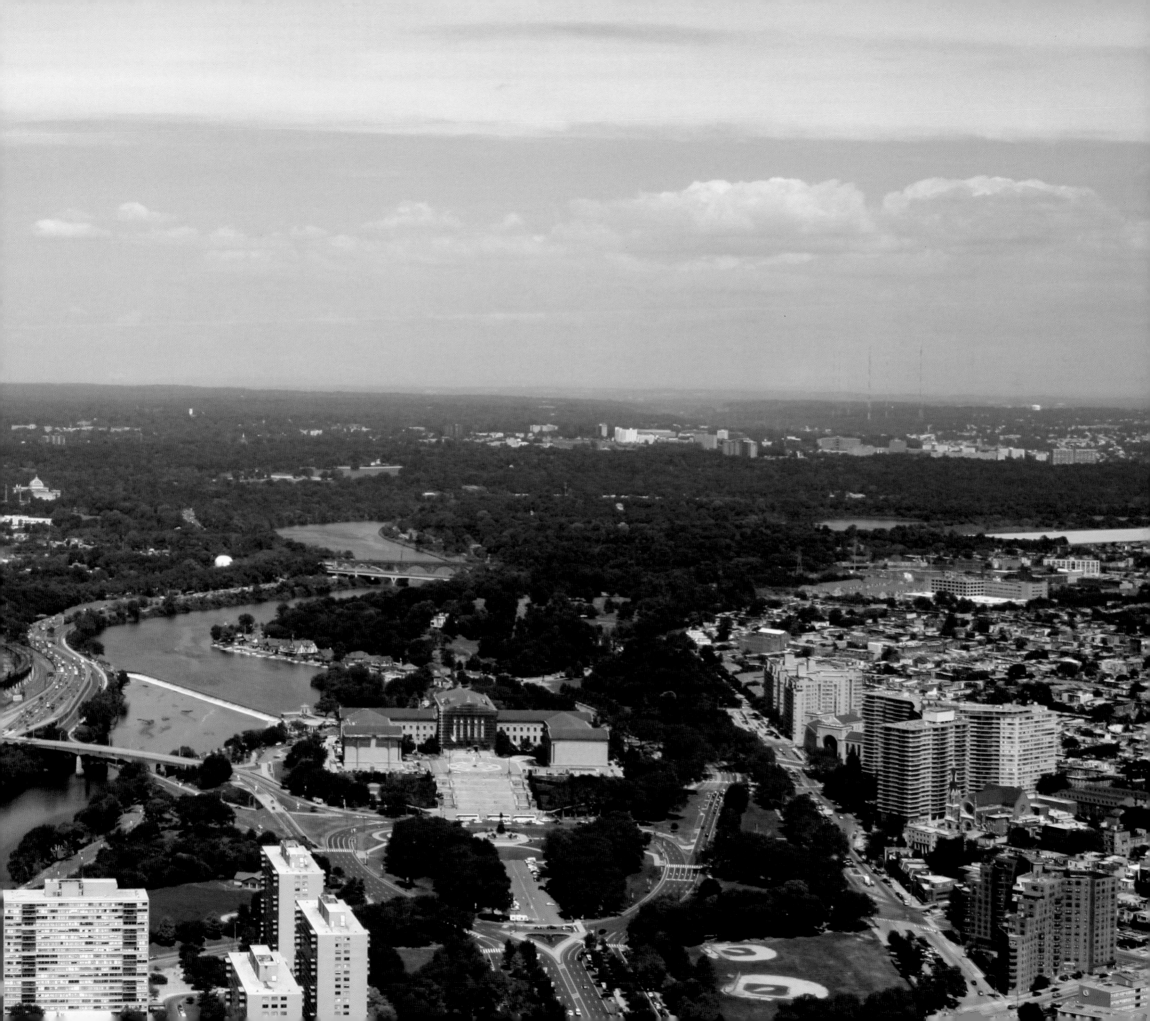

Life on the rooftops (l to r): basketball and
tennis courts, reading and study patio,

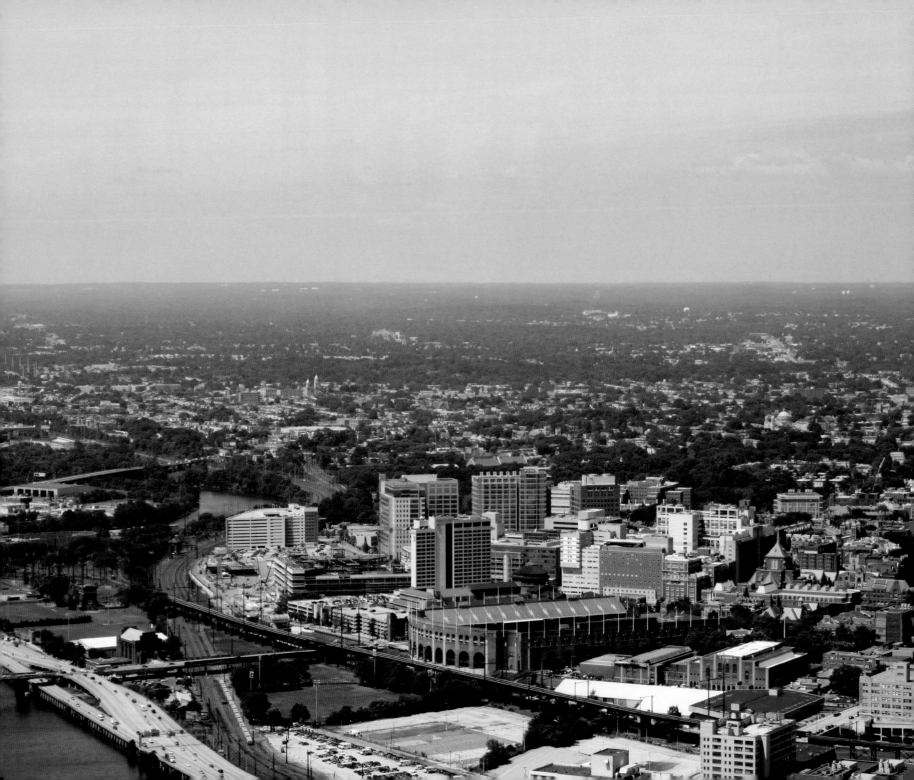

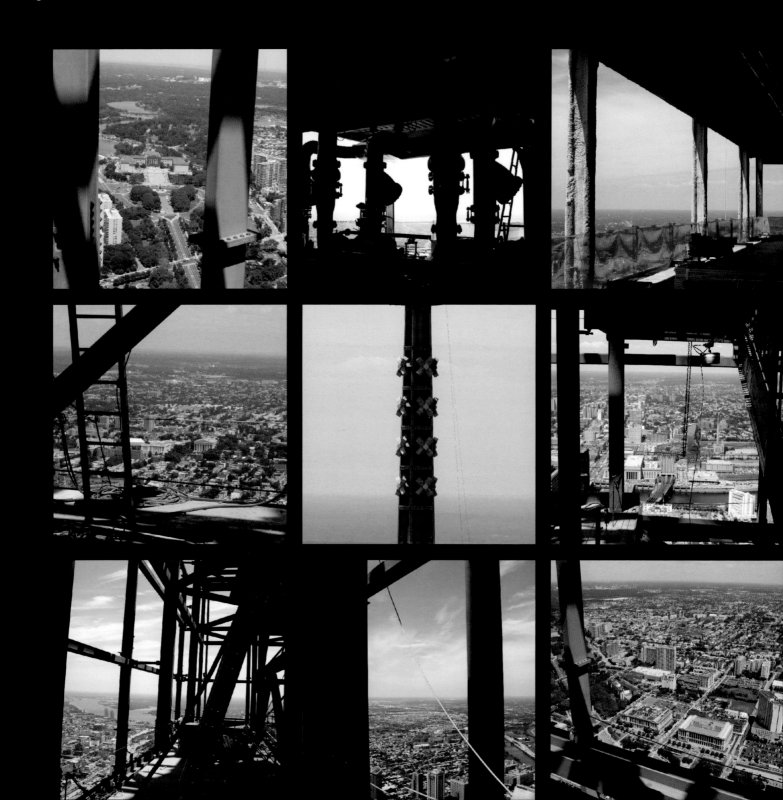

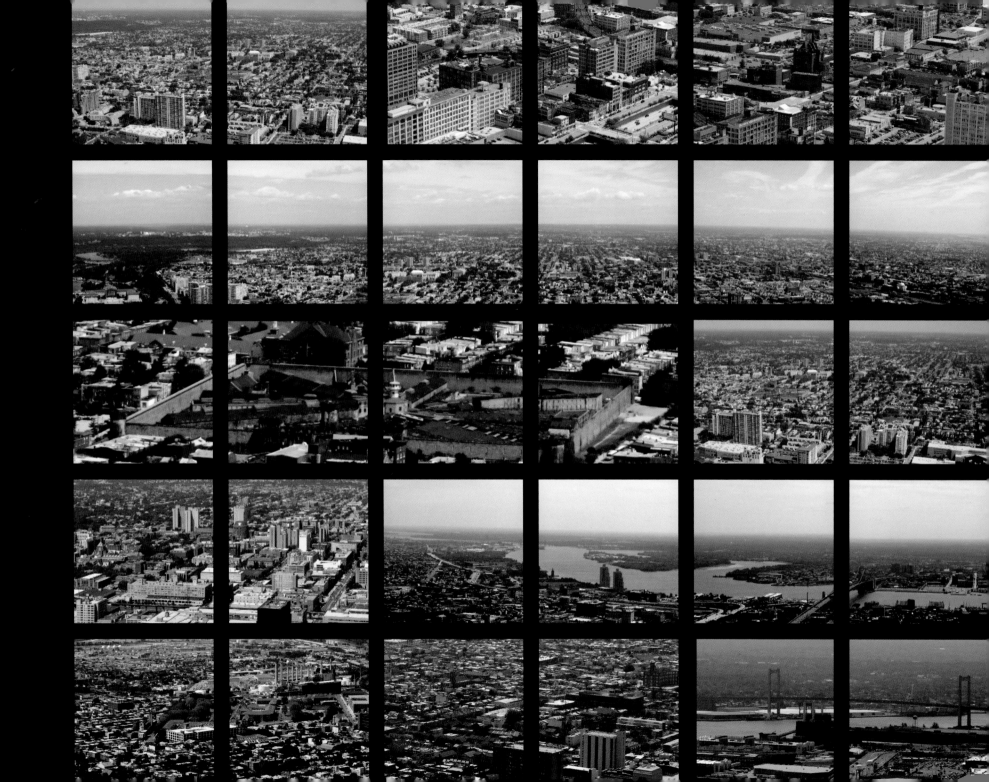

North

East

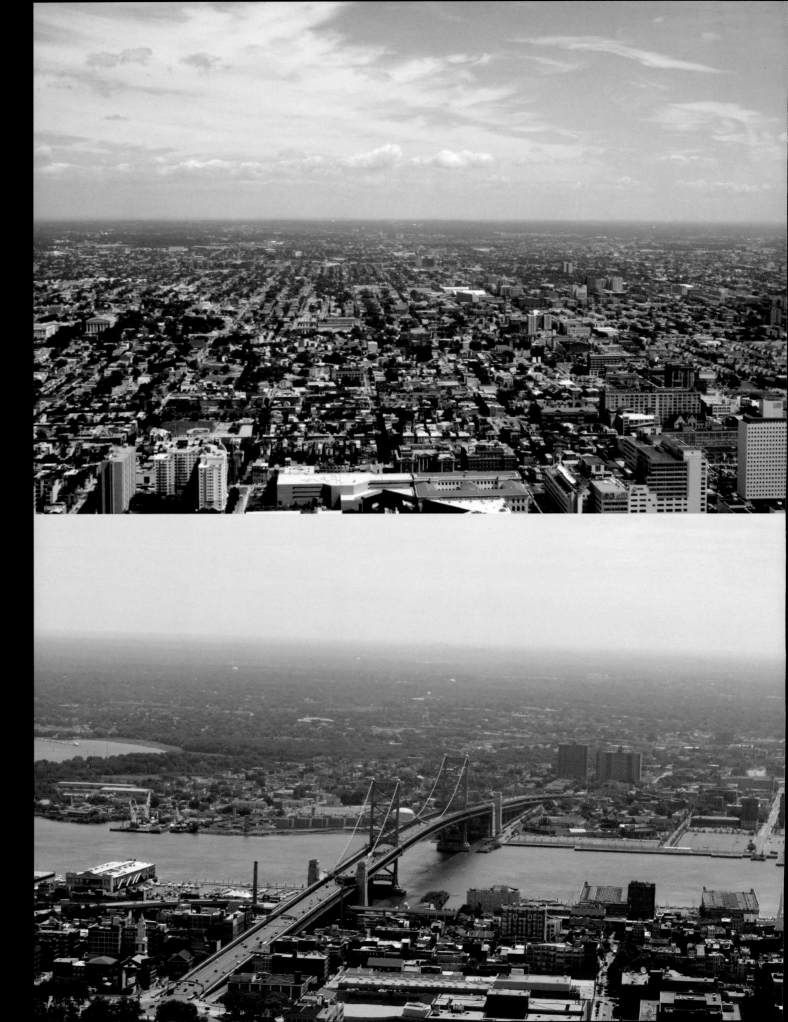

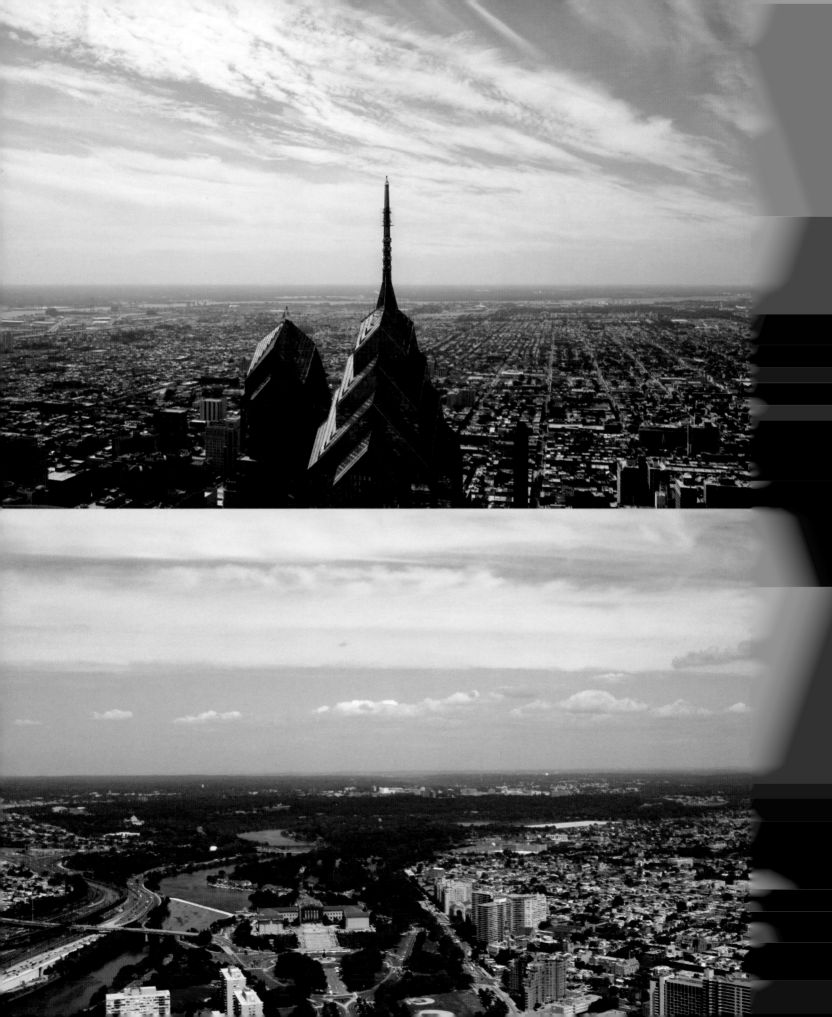

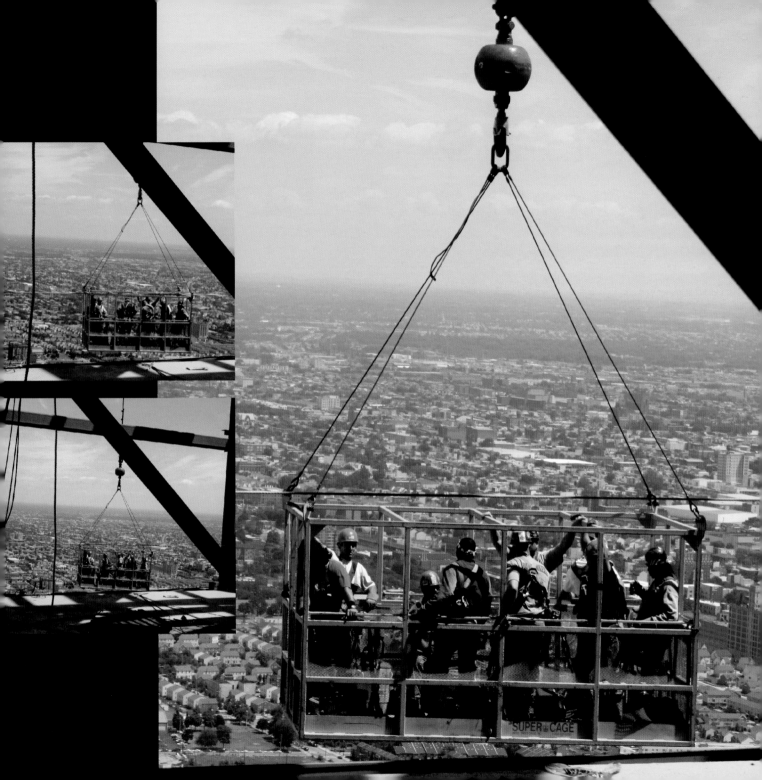

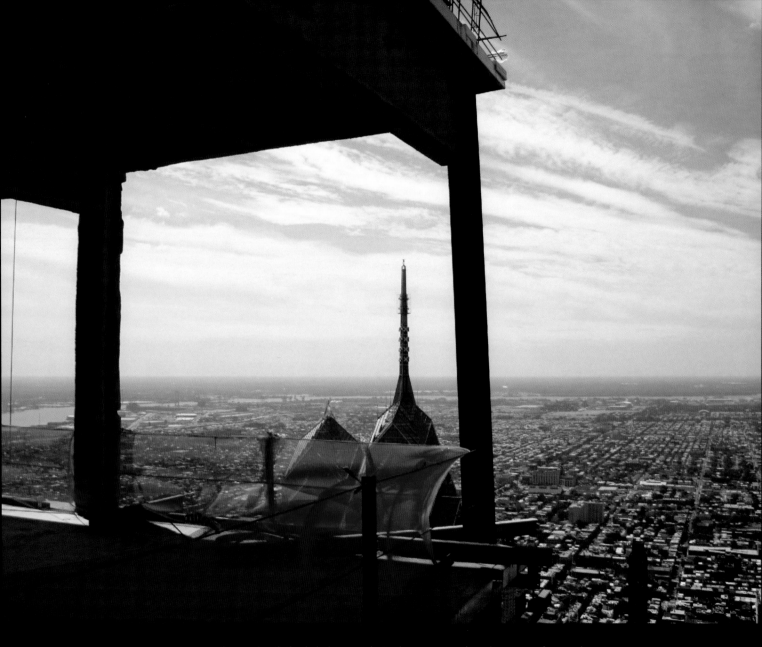

Above and opposite page: views of South Philadelphia with Delaware in the distance from the Comcast Center perspective.

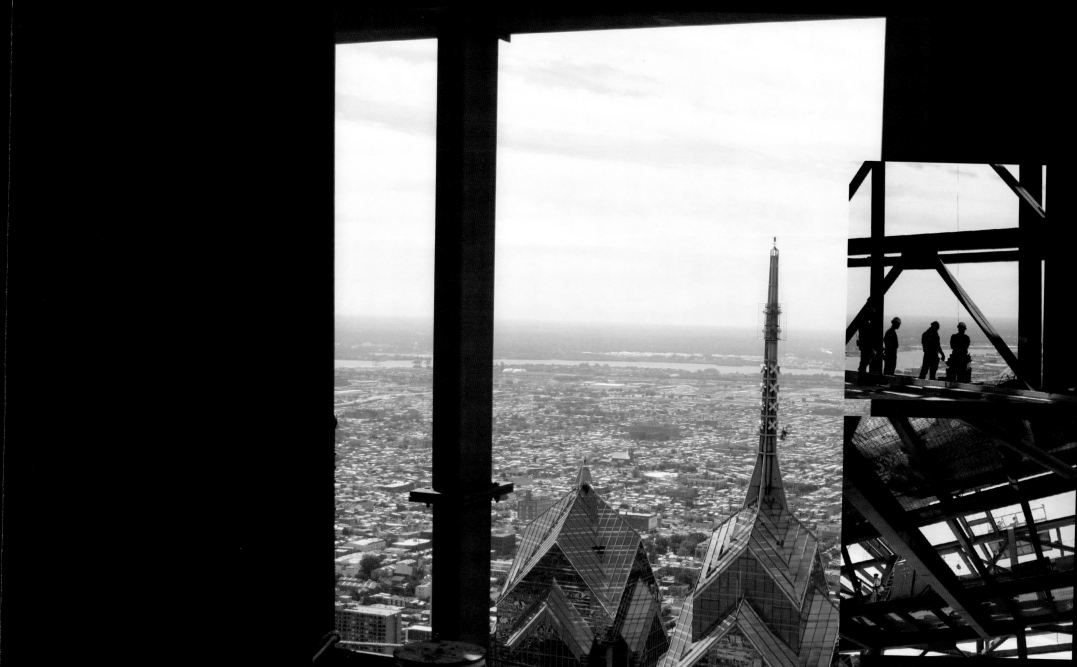

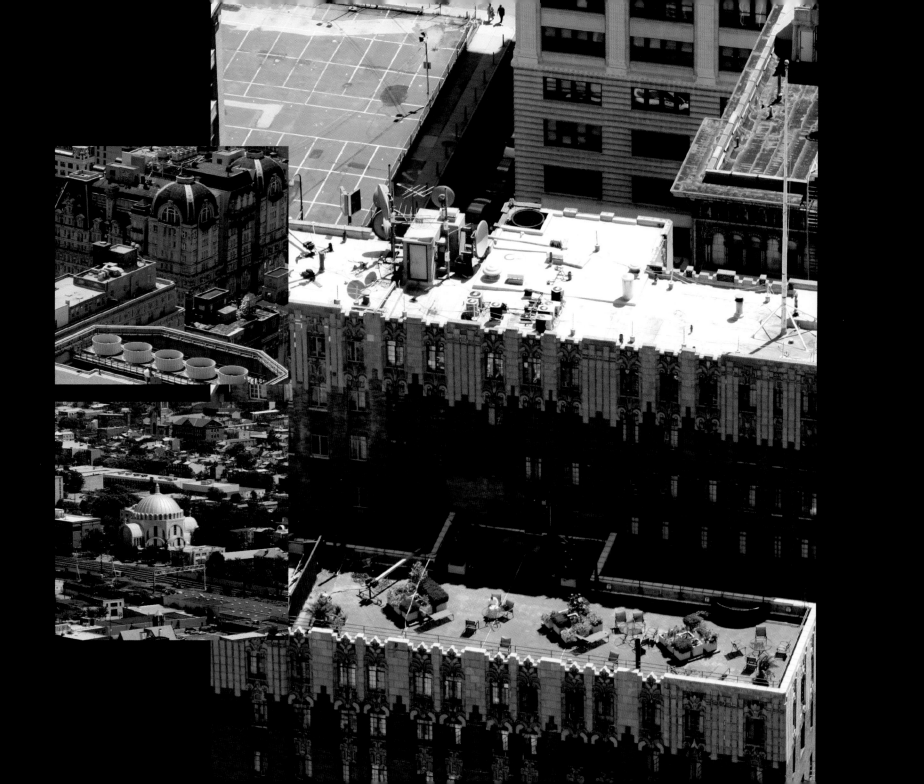

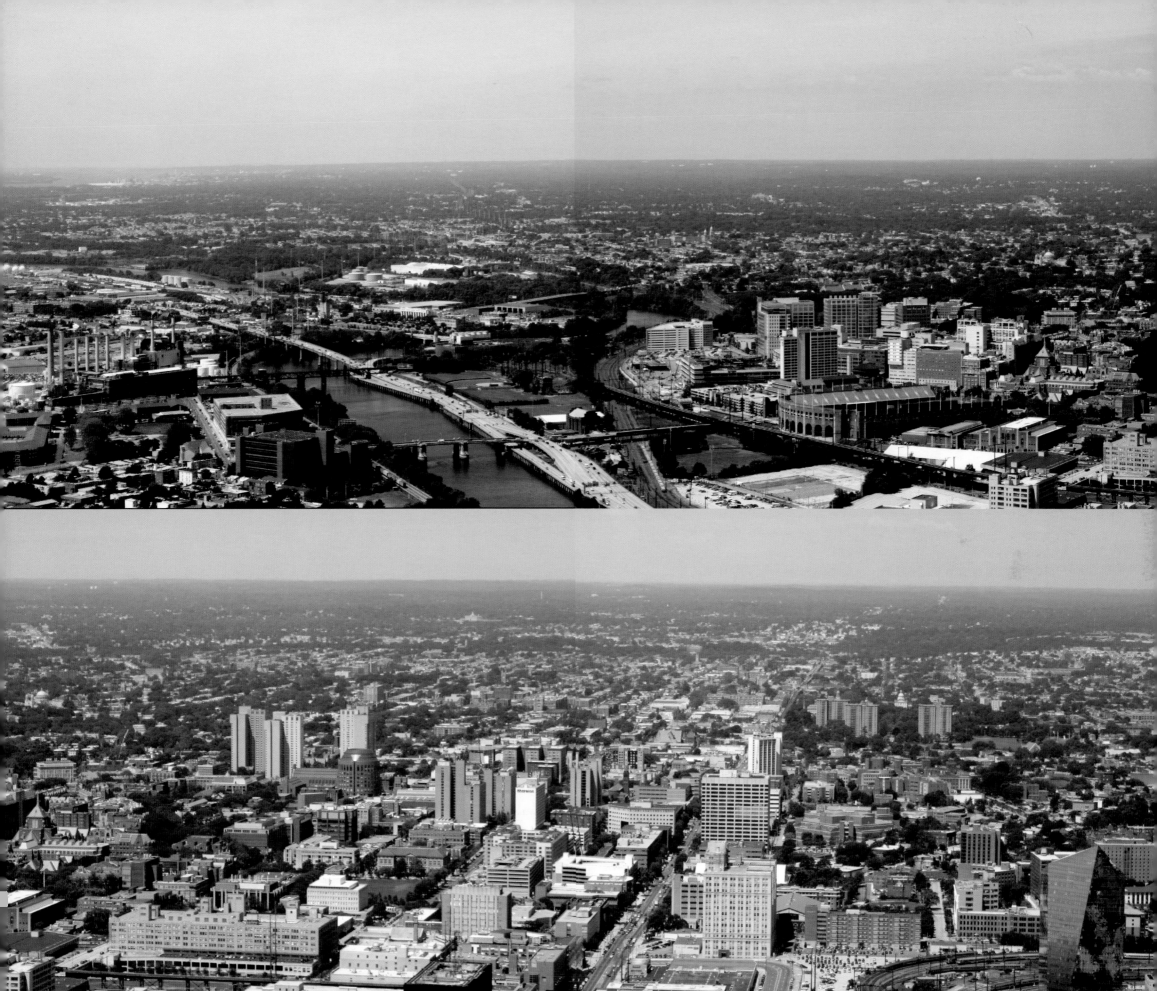

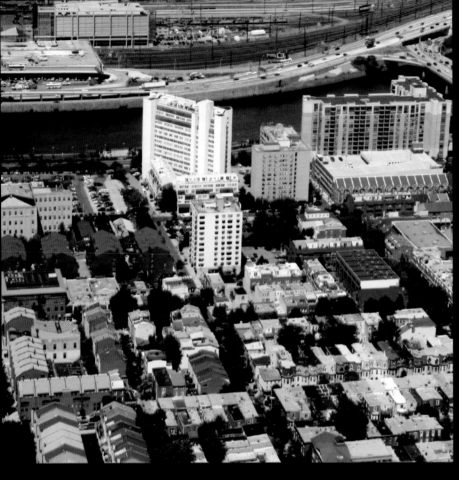

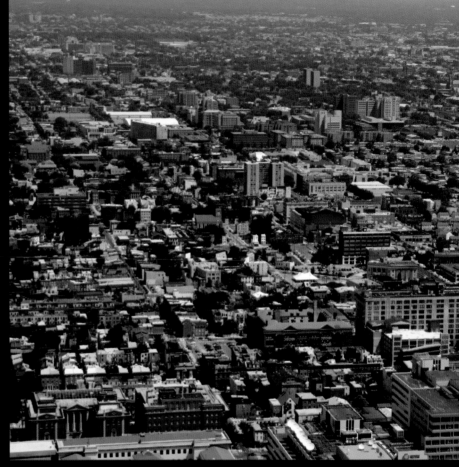

Above and left: Philadelphia neighborhoods to the east and west of Center City.

Opposite page: the Blue Cross/Blue Shield and Verizon buildings and surrounding neighborhoods west of Center City.

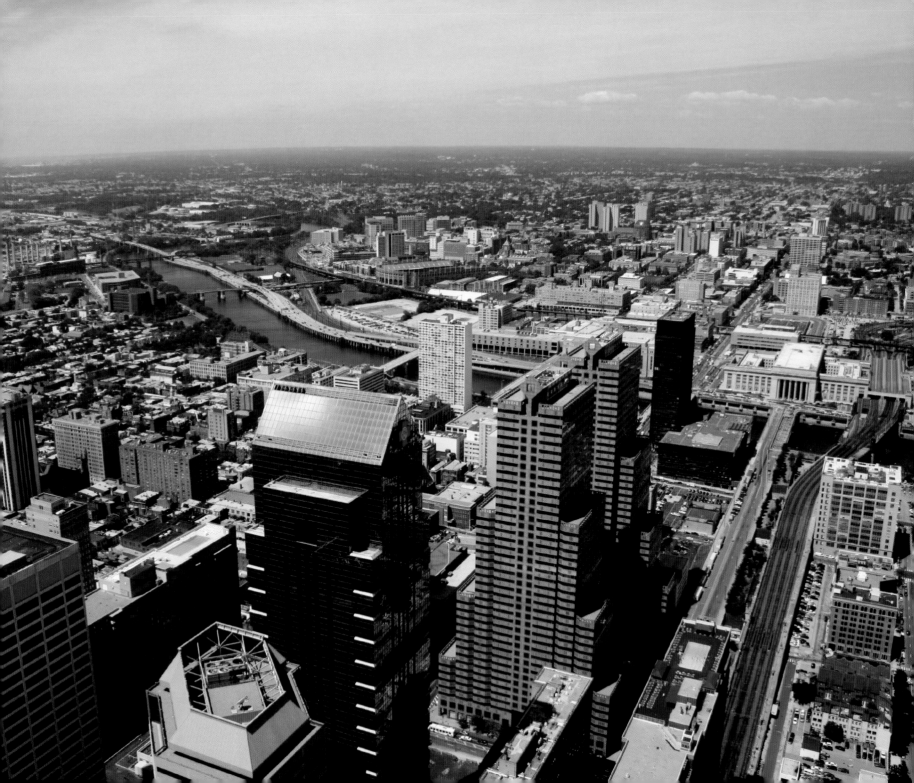

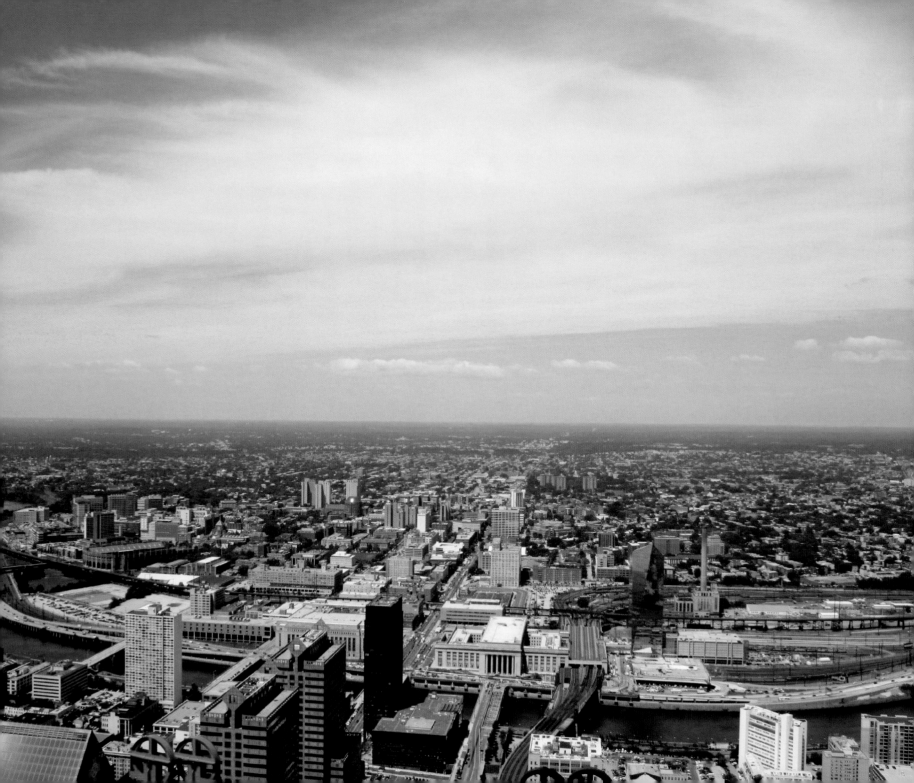

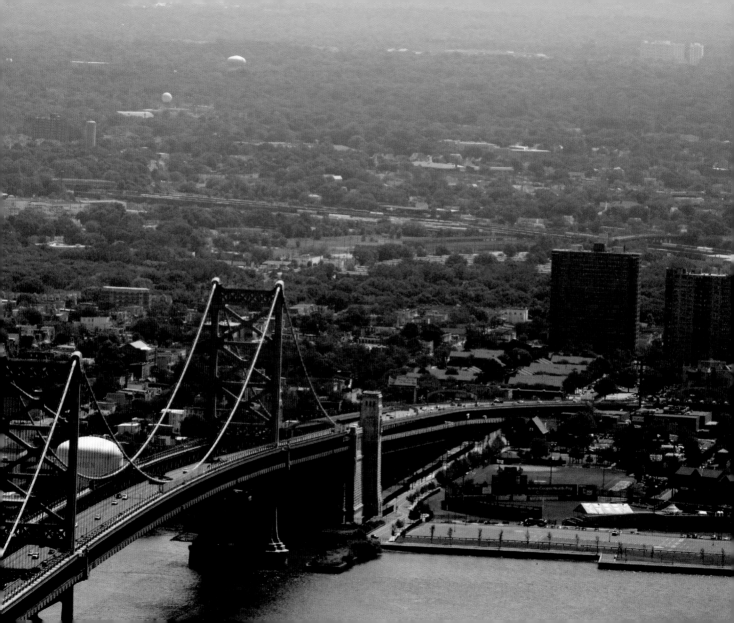

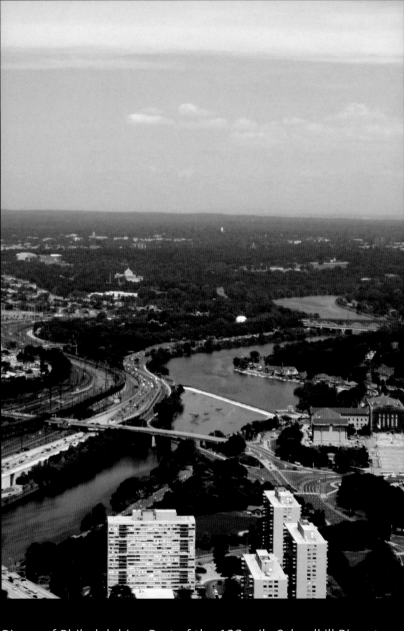

Rivers of Philadelphia: Part of the 128 mile Schuylkill River to the north and west of Philadelphia

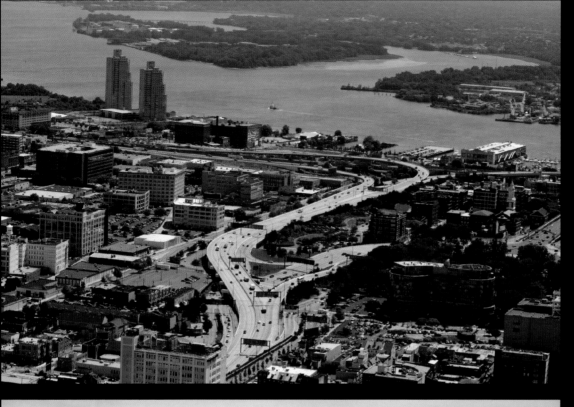

Rivers of Philadelphia: Part of the 410 mile Delaware River to the east of Philadelphia creates the Pennsylvania and New Jersey border

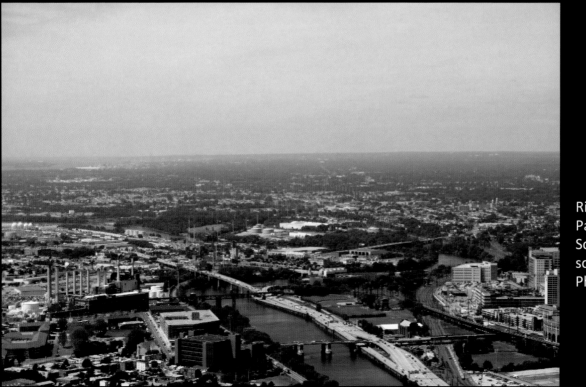

Rivers of Philadelphia: Part of the 128 mile Schuylkill River to the south and west of Philadelphia

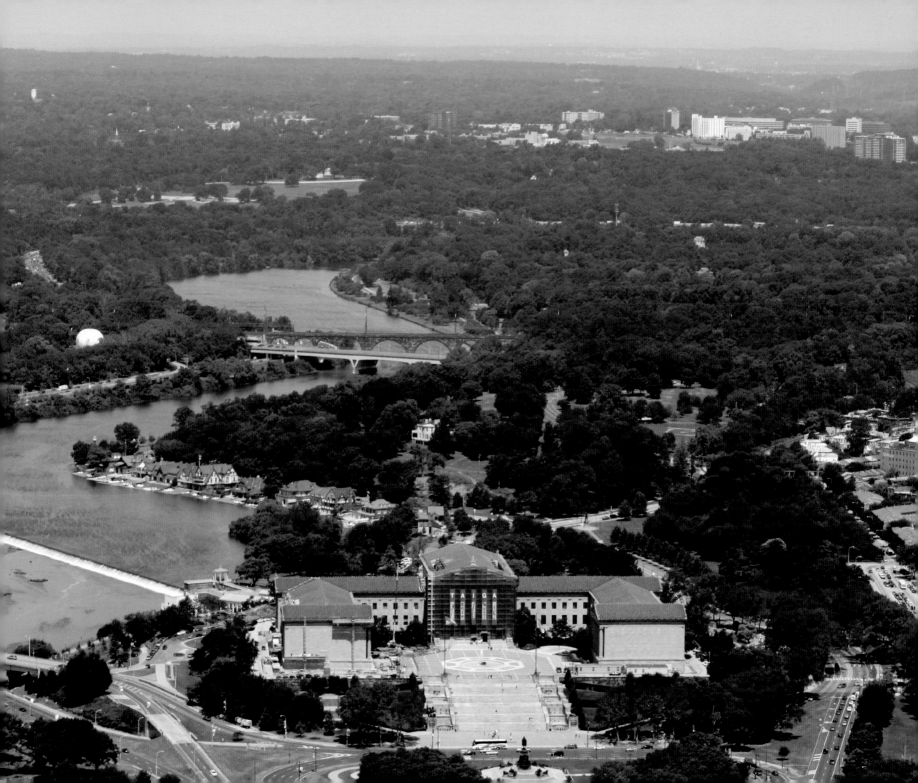

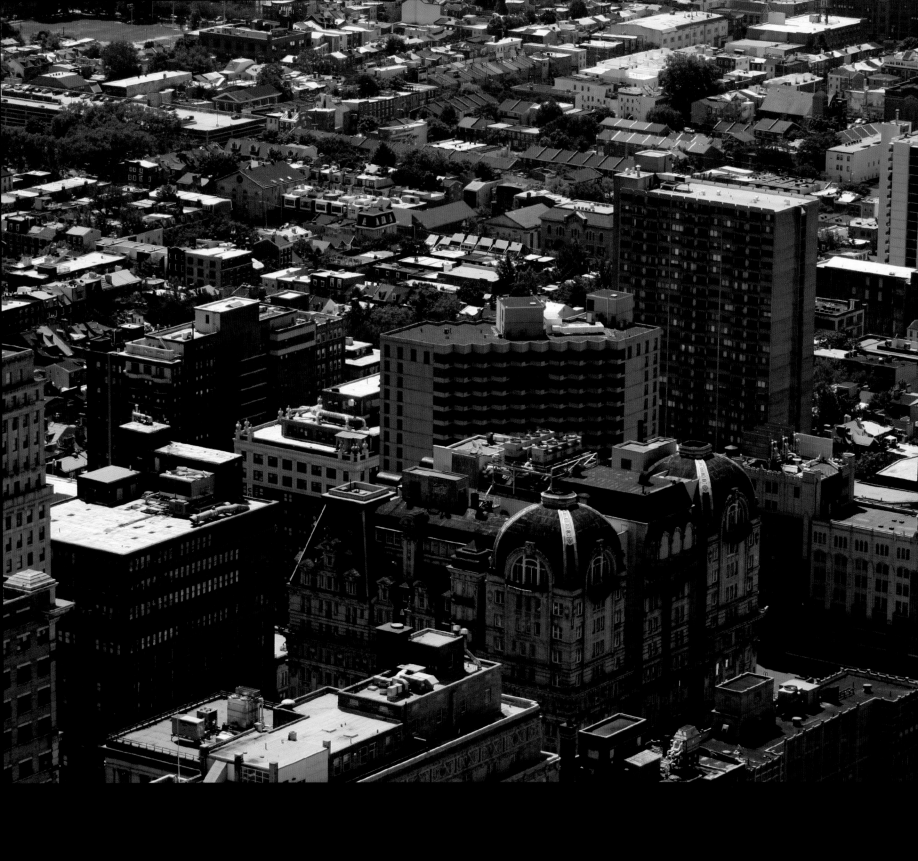

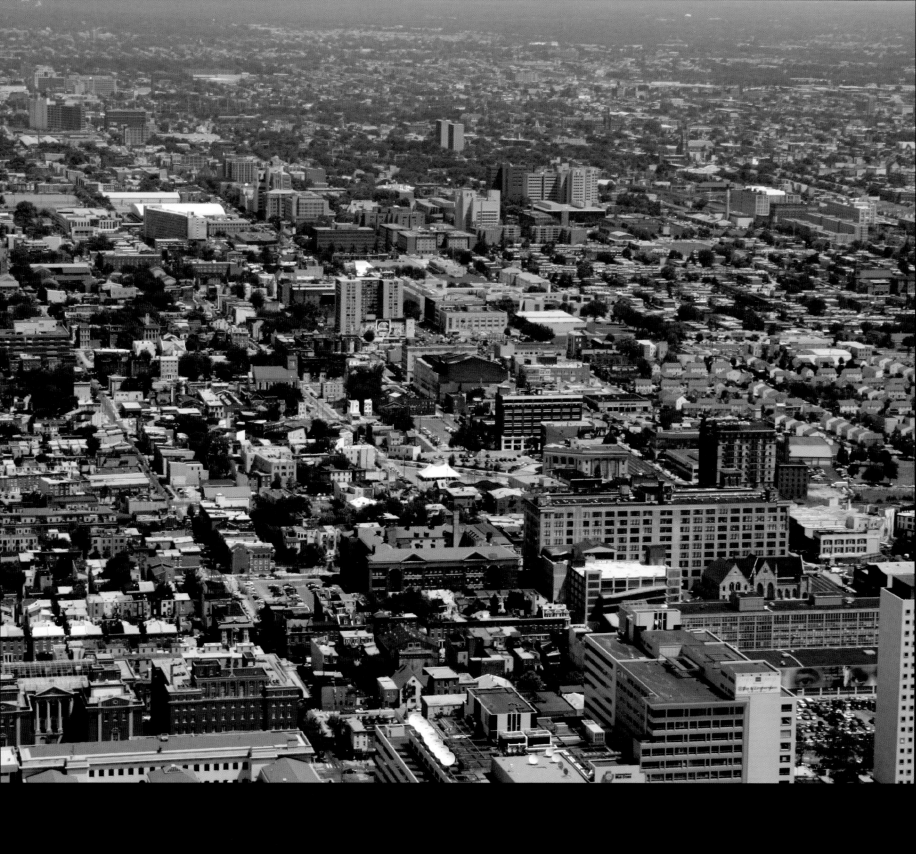

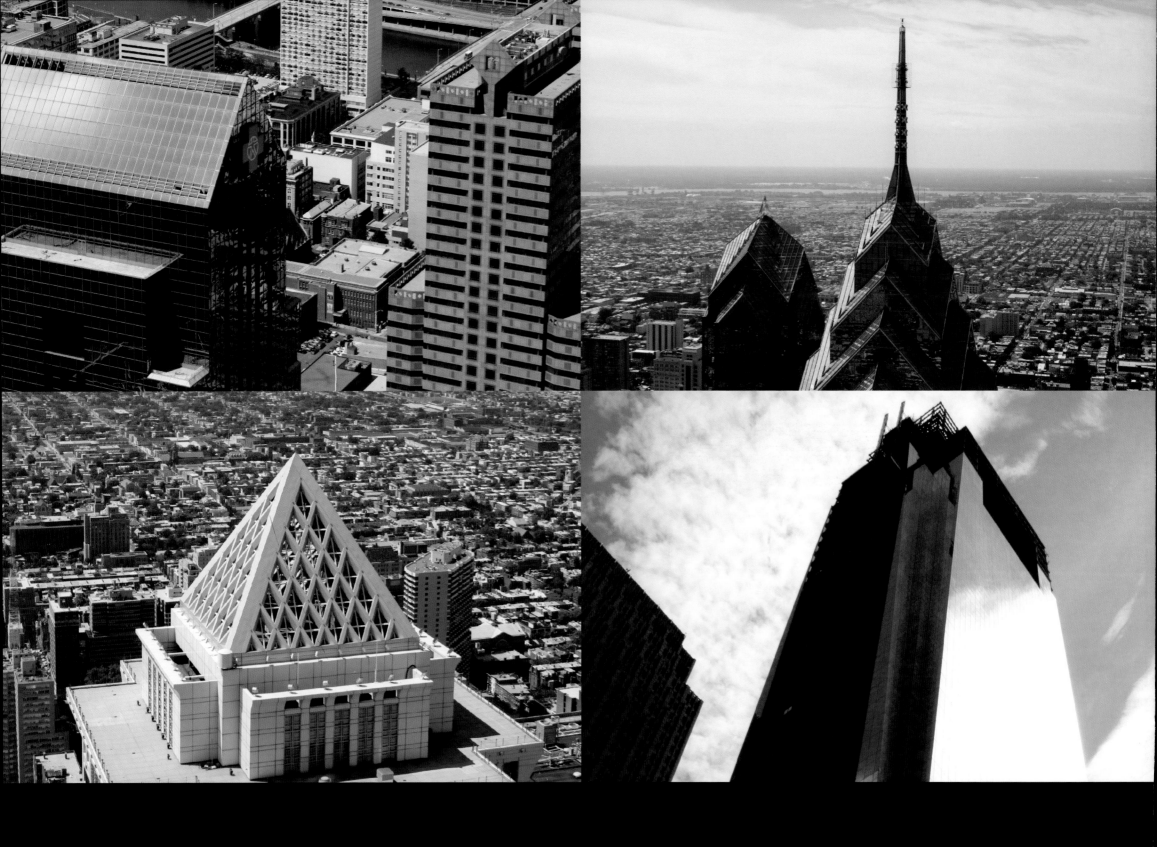

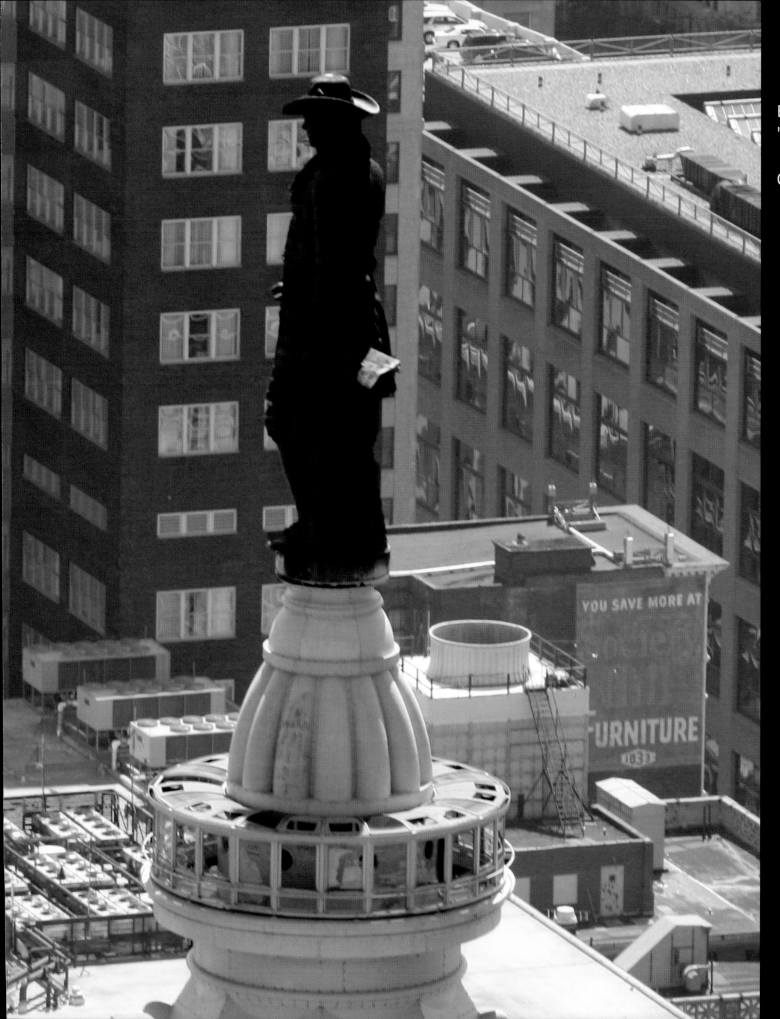

Billy Penn (548 ft, 1901) contemplates "The Curse" :

Opposite page left to right:

Blue Cross Tower (700 ft, 1990)

Verizon Tower (739 ft, 1991)

Two Liberty Place (848 ft, 1989)

One Liberty Place (947 ft, 1987)

Mellon Bank Center (792 ft, 1990)

Comcast Center (975 ft, 2008)

The alleged curse refers to the fact that since One Liberty exceeded Billy Penn's height in 1987 no major Philadelphia sports team (baseball, football, basketball or hockey) has won a league championship. The last championship was an NBA victory by the 1983 Philadelphia 76ers.

The Art Museum

The Ben Franklin Parkway showing the Free Library of
Philadelphia and it's twin Family Court Building, the
Franklin Institute and Logan Circle.

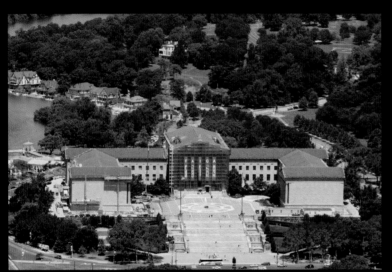

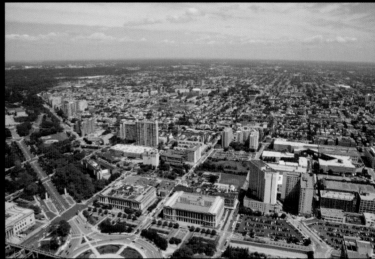

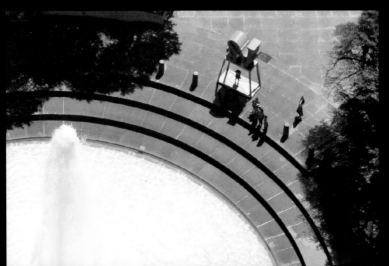

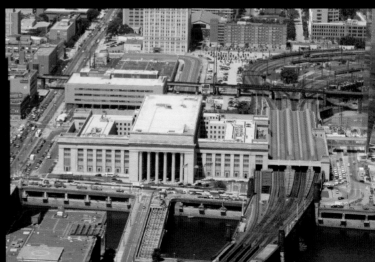

Boat House Row

City Hall

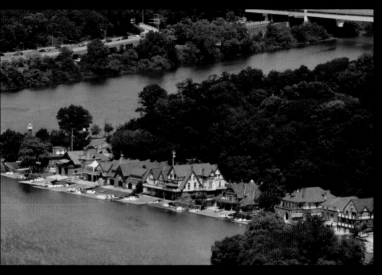

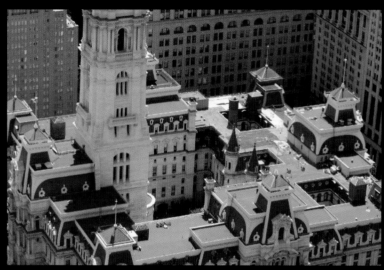

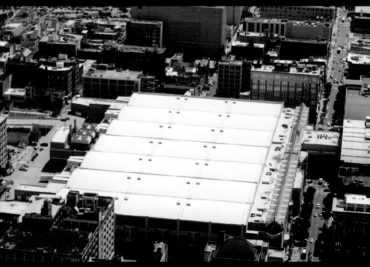

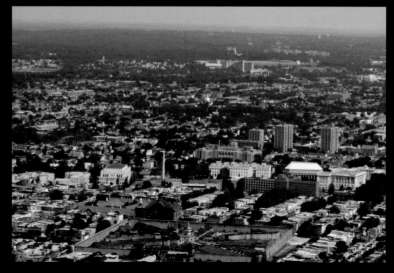

The Convention Center

Eastern State Penitentiary

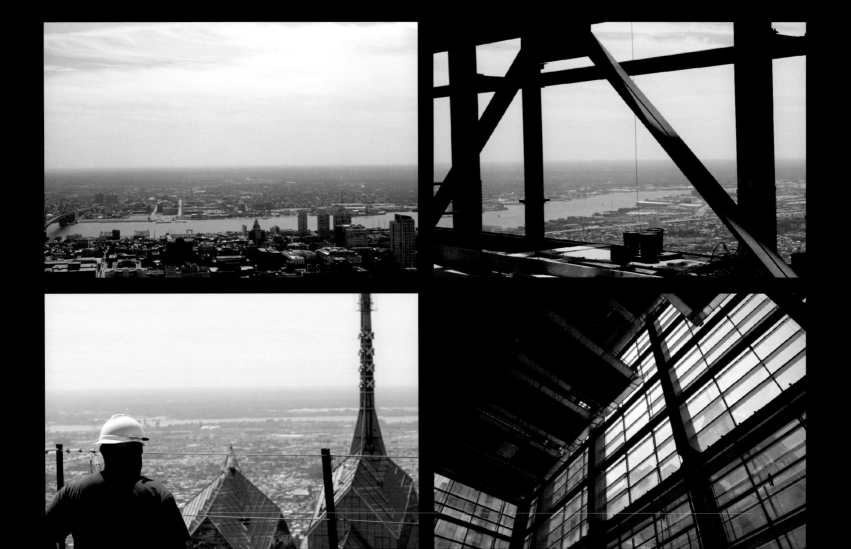

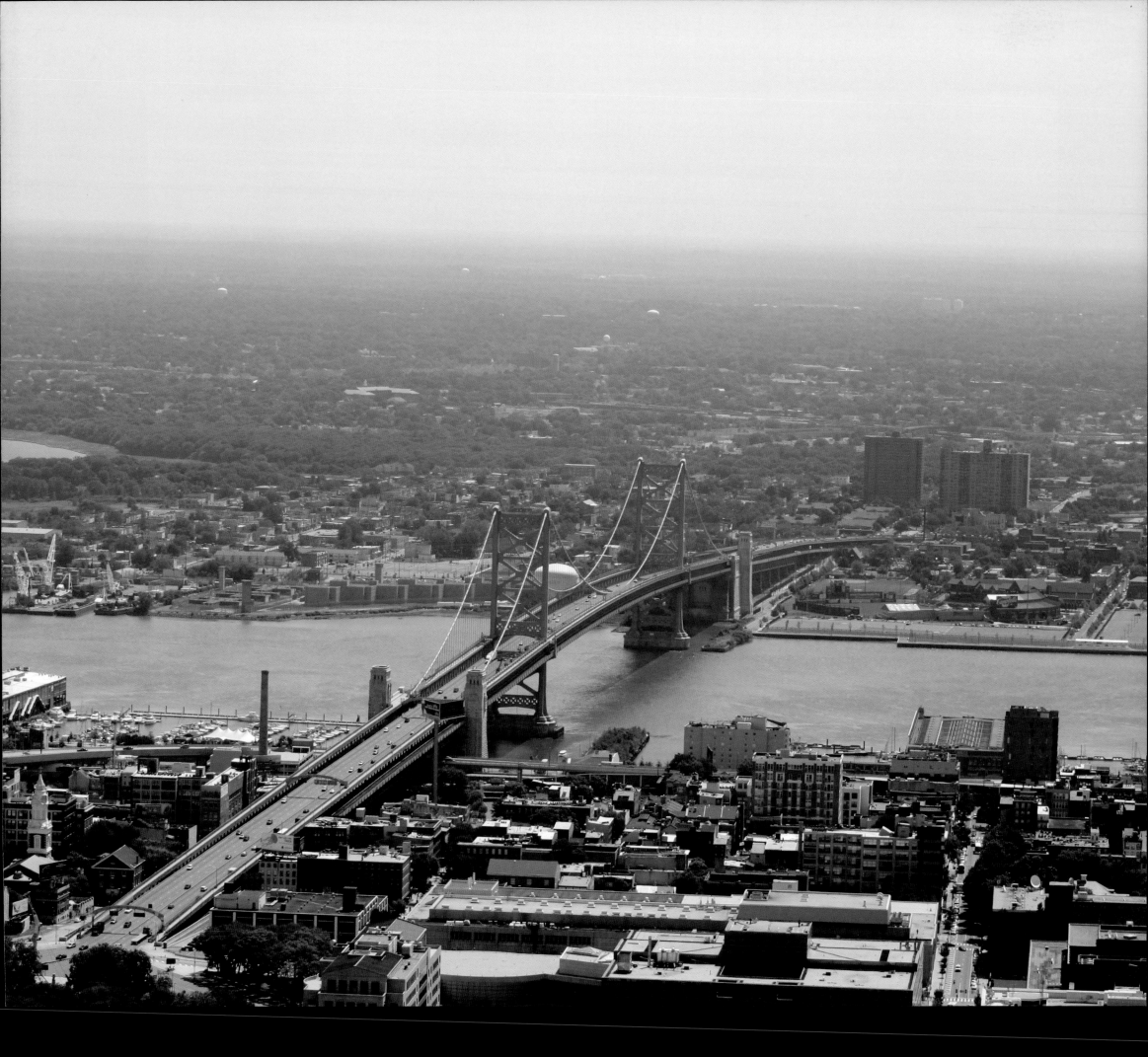

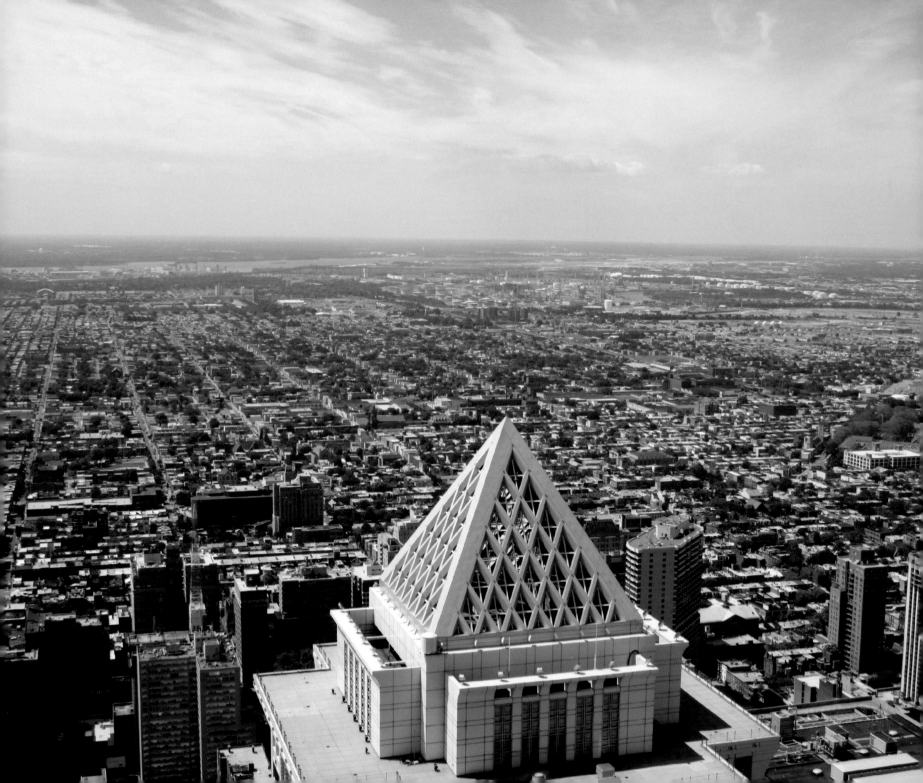

Opposite page and left:
The South Philadelphia
Views

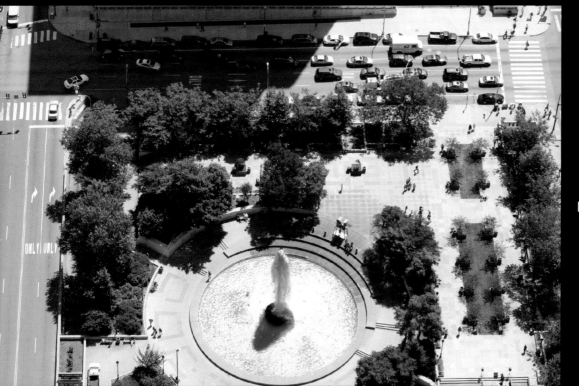

Love Park from on high

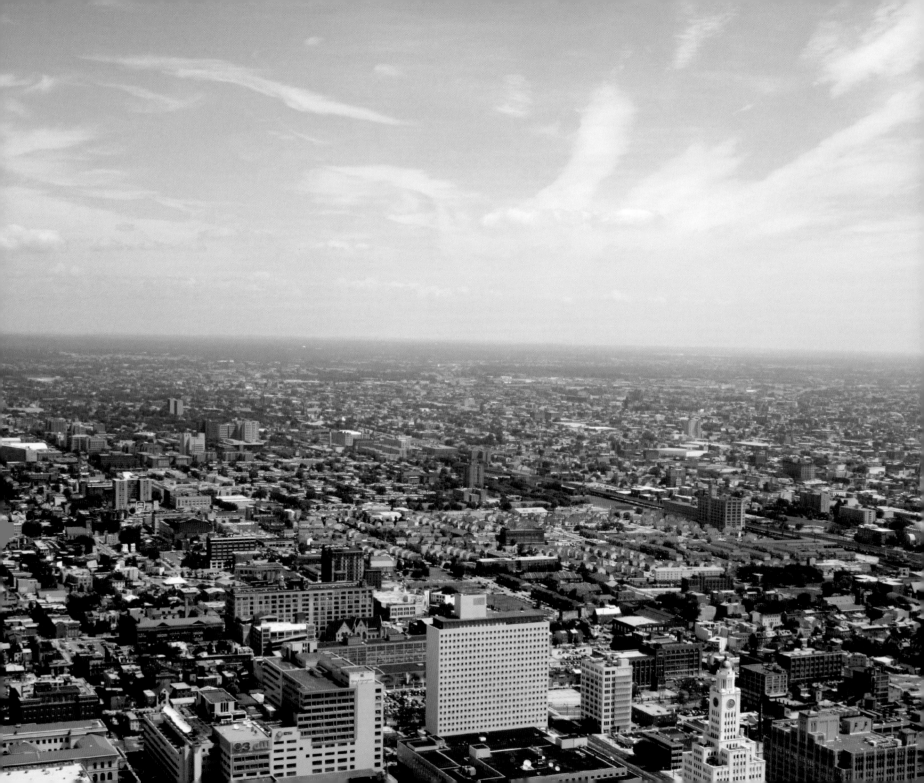

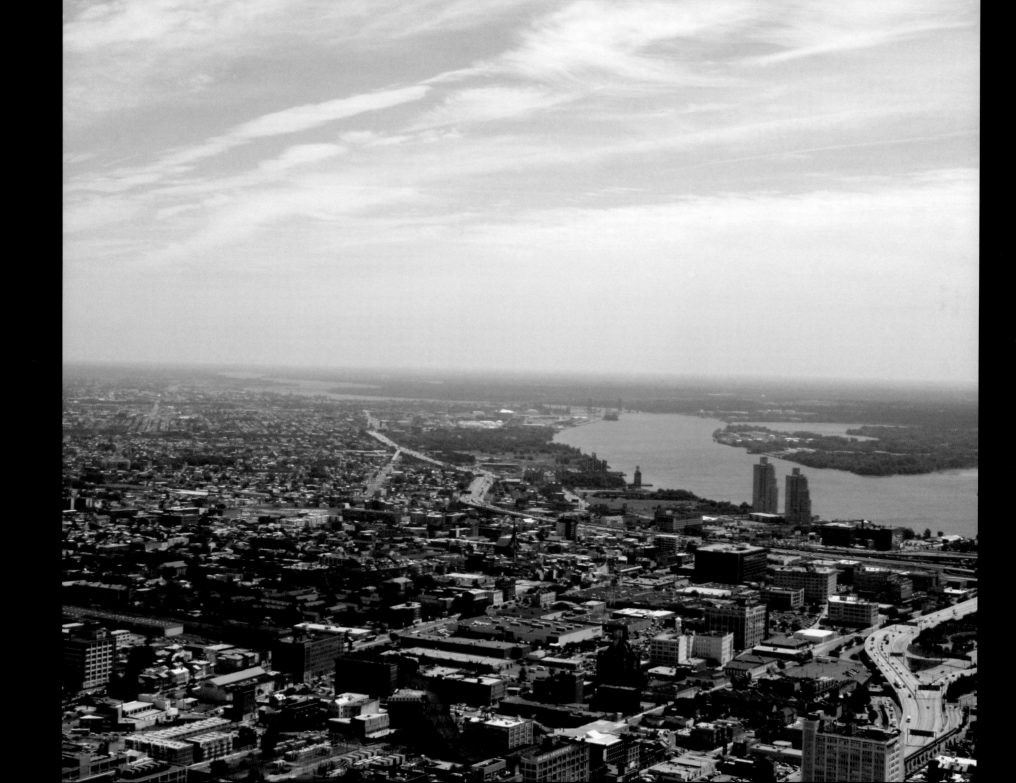

blurb.com